Postcards from

Utopia

The Art of Political Propaganda

Introduction by
Andrew Roberts

The publisher would like to thank John Pinfold and John Nichols for their generous help in producing this publication.

First published in 2009 by the Bodleian Library
Broad Street
Oxford OX1 3BG

www.bodleianbookshop.co.uk

ISBN: 978 1 85124 337 2

Introduction © Andrew Roberts, 2009
This edition © Bodleian Library, University of Oxford, 2009

Designed by Dot Little
Printed and bound in China by C&C Offset Printing Co. Ltd.
British Library Catalogue in Publishing Data
A CIP record of this publication is available from the British Library

Collector's Foreword

From an early age I was interested in history. My mother gave me my first postcard, of King George VI at his coronation. When she took me to St Paul's Cathedral, I bought a postcard of Nelson's statue. In 1944 my local Woolworths sold sepia photographic postcards of generals Eisenhower, Alexander, and Montgomery. From then on I was a compulsive collector of any postcards of a historical or current political interest.

I was strongly influenced by the example of my artist aunt, Helen McKie (pronounced to rhyme with key). She had a large collection of postcards, mainly of views, arranged in order of country and subject matter, which she used for reference purposes. So I had her example to follow, and after her death I acquired her postcards of Hitler (she was the first woman artist to be allowed in the Brown House when she was commissioned to do a series on Germany in 1932 for the *Sketch*) and also cards of Rome with its Fascist décor. (There is an entry for her in *Who Was Who* for the 1950s.)

John Fraser, London

Introduction

There is something in the human psyche that makes us want to believe in a future state or political system that can deliver perfect justice, happiness, and equality here on earth. In 1516, the theologian Sir Thomas More wrote a book entitled *Utopia*, and ever since then thinkers have been trying to devise ways to bring about such a place, while unscrupulous politicians have never stopped promising to build one. The fact that they have all failed for over half a millennium ought to have taught us that utopias—like the beautiful sirens' voices to seamen of ancient myth—mask a potentially lethal trap.

When in a totalitarian regime, every organ of the state is dedicated to delivering a central message, postcards are one of a large number of media that can be employed. This excellent collection of postcards relating to political utopias was amassed over a lifetime by John Fraser and then very generously donated to the Bodleian Library in Oxford. It reminds us how often we have been sold the idea of a political and social heaven on earth—such as the Communist vision of a Workers' Paradise—and how often we have fallen for what Joseph Goebbels called 'the Big Lie'.

The artistic representations of utopia require for their success a suspension of disbelief on behalf of the viewer. As one enters the main gate of Auschwitz, there is the motto wrought in iron: 'Arbeit Macht Frei' (Work liberates). In every Nazi, Soviet, and Maoist representation of physical labour there is a joyousness that we rationally know is entirely missing from the long, hard slog of true manual work in fields. Most people's idea of utopia involves the absence of grinding, back-breaking work, yet these postcards try to sell us the very opposite line. Perhaps that is why tractors appear so often in Twenties and Thirties totalitarian iconography, as the ultimate in modern technological advance and labour-saving devices.

Similarly, the evidence of our eyes tells us that not everyone is lovely looking, except in totalitarian poster —or in this case postcard—art. Just as every female peasant farmer is beautiful in utopian representations of the proletariat, so each male is a muscle-bound demi-god. This is propaganda so crass as to be absurd, but it seems to have worked. Here is Adolf Hitler, for example, represented most unconvincingly, in a silver suit of armour and—even less convincingly—sitting astride a huge black horse. 'Der Bannerträger' (The banner-carrier) is as unlikely

a pose as it is possible to imagine the Führer adopting in real life, yet with suspension of disbelief almost anything can be achieved. The eagle clutching the swastika in the postcard for the Nazi Party Day at Nuremberg seems to soar above the stadium, caught in the beam of the military searchlights. With Leni Riefenstahl organizing the filming, Dr Goebbels choreographing the giant torchlight processions and providing the warm-up speech, and Speer building the vast stage sets for the rallies, Hitler had charisma created artificially for him.

Russian memorials to the Second World War are easily the finest in the world, and the city of Volgograd (formerly Stalingrad) is dominated by a magnificent statue of Rodina Mat (Mother Russia) that is over 250 feet high, erected on the summit of the Mameyev Kurgan, a hill that is also the resting place for the 35,000 people who died fighting for its control. The sword she wields weighs fourteen tons alone. It is an utterly breathtaking sight and the whole battlefield is instantly comprehensible from the top of it, rather as climbing the Lion Mound puts everything into immediate perspective at Waterloo. One can imagine how the postcard included in this collection would engender

feelings of immense patriotism in any Russian. Yet the reality of the life of Russian women during the Second World War—especially during the battle of Stalingrad —was unrelentingly ghastly, as the total of twenty-seven million Soviet war dead implies.

The difference between the heroic image and the monstrous reality of war is of course ignored by propaganda art. The postcard of the teenage Hitler Youth with his own future Wehrmacht officer-self shadowed behind—complete with Iron Cross and coal-scuttle helmet—must have made many a young German heart beat faster in 1939–44, but in the last twelve months of the Reich, fourteen-year-olds were indeed being conscripted into the Volkssturm units to fight and die for their Führer.

The idealized view of V. I. Lenin in this collection— learning at his mother's knee, walking in the woods, teaching peasants, helping to carry telegraph poles across Red Square—bears little relationship to the opportunistic dictator of real life, just as Chairman Mao's well-fed and smiling supporters clutching the *Little Red Book* in one hand and Kalashnikovs in the other, bear no resemblance

to the many millions who died of starvation or were executed during his regime. Yet such is our psychological need to feel that we can return to the Garden of Eden that humans seem to be able to put up with any kind of misrepresentations if a utopia is offered with seeming sincerity.

'Credere, obbedire, combattere' (Belief, obedience, combat) is the demand made by Mussolini's postcard. Belief in the Duce himself, obedience to his will, and willingness to fight for his cause are not much different from the demands made by others of these postcards from the Spanish Civil War, wartime Hungary, the Vietnamese Communist Party and of course Comrade Stalin, depicted here in all his simplicity and decency. The essential fraudulence of it all—with sunlit uplands, wheatfields groaning in abundance, and of course the ubiquitous tractors—changed little from regime to regime between the Twenties and the Seventies.

Socialist realism and Fascist *Kultur* (culture) never made great art, but they did create fascinating postcards. They show the contempt both ideologies ultimately felt for the masses they ruled over, believing that they could offer earthly bliss while delivering little more than poverty, terror and war. In one postcard in this collection, a Chinese female communications engineer is up a telegraph pole, fixing a line in the pouring rain, and seeming to love every minute of it. These postcards ought to help undermine any future *credere* in and *obbedire* to the promise of an earthly utopia.

Andrew Roberts

The Postcards

V. I. Lenin on a tribune

This 1930 painting by Gerasimov is a classic socialist realist image of Lenin addressing the crowds at a May Day rally after the Revolution. It was common in such paintings to depict Lenin dominating the scene and leaning forward into the wind, with a cloudy or stormy sky behind. The message was clearly that revolutionary socialists could face the future with confidence and would successfully overcome any obstacles in their way to a sunnier time ahead.

The caption on the rear of the card describes Lenin's talent and ability at delivering speeches to different audiences, his skill at linking theoretical issues to practical life, and his ability to find the right way of speaking to specific audiences. It claims that in his speeches he never avoided sharp, complicated or difficult issues; on the contrary he raised these questions and then answered them directly.

This description of Lenin's style of oratory is largely borne out by eye-witness accounts.

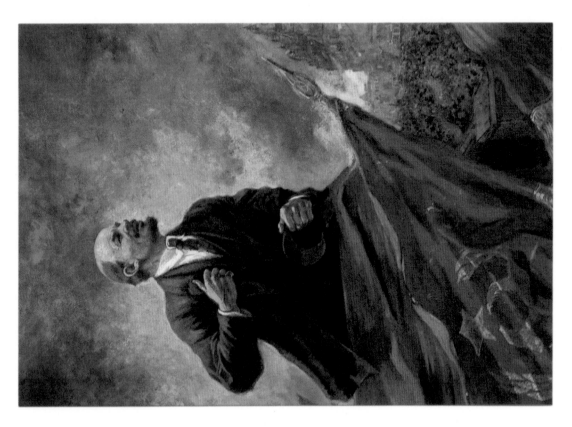

МЕЖДУНАРОДНАЯ
КНИГА

Современная историческая эпоха, начало которой положила Великая Октябрьская социалистическая революция, характеризуется все более широким распространением бессмертных ленинских идей, стоящих подлинным властителем дум всего передового человечества. Неразрывно связанное с жизнью учение Ленина постоянно развивается на основе обобщения достижений науки, новых исторических явлений, классовой борьбы современного рабочего класса, повседневной практики социалистического и коммунистического строительства. С каждым поворотом истории, в связи с новыми данными в экономической и политической жизни общества, величием открытиями в науке торжество ленинизма обогащается. Ход истории приносит новые и новые подтверждения правоты мыслей и дела Ленина.

Вникнувших на прочной базе марксизма, ленинизм обобщил опыт трех русских революций, оказавших могучее влияние на развитие национально-освободительных, демократических, революционных движений XX века;

раскрыл исторический опыт построения социализма в СССР, обосновал его общие закономерности и характерные особенности;

показал советский опыт создания многонационального социалистического государства, решения сложнейшего национального вопроса;

обобщая в новую историческую эпоху не только опыт российского, но и всего международного революционного движения;

явился идейной основой воспитания коммунистов, рабочего класса, всех трудящихся в духе высоких принципов международной солидарности в борьбе за мир, за безопасность и свободу народов, за социальный прогресс.

Наиболее полно ленинские предначертания, его мечты, мудрые, благородные идеи и заветы осуществлены в Советском Союзе. Читайте:

Брежнев Л.И. „Отчет ЦК КПСС XXVI съезду КПСС и очередные задачи партии в области внутренней и внешней политики"

Тихонов Н.А. „Основные направления экономического и социального развития СССР на 1981–1985 гг. и на период до 1990 года"

„XXVI съезд КПСС". Стенографический отчет.

Серов В. С Лениным

With Lenin

This card reproduces a painting by Vladimir Serov (1910–68), who after being a member of the Association of Artists of Revolutionary Russia, became a leading exponent of socialist realism. Although socialist realist art has often been criticized as neither expressing socialism nor being very realistic, its key claim was that it expressed the truth of the social and political order. Thus, socialist realism was supposed to transcend history, and although Lenin may never have walked across a cobbled street with a crowd of resolute workers behind him, this was the 'poetic truth' of revolutionary history. It is interesting that although Lenin is depicted as clearly leading the crowd, he is also seen as being on the same level as them; the prominent cobblestones no doubt represent the hard road ahead to build the socialist utopia.

The caption on the back of the card relates to the Twenty-fifth Congress of the Communist Party of the Soviet Union, held in 1981. In part it reads:

> The modern historical epoch which began with the Great October Socialist Revolution is characterized by a wider and wider circulation of the immortal Lenin's ideas. Indissolubly linked with life, Lenin's doctrine is constantly developing in accordance with achievements in science, new historical phenomena, the class struggles of the modern working class, and the daily practice of building socialism. The course of history brings ever more acknowledgement of the correctness of Lenin's ideas. Lenin's dreams, ideas, and precepts are fully carried out in the Soviet Union.

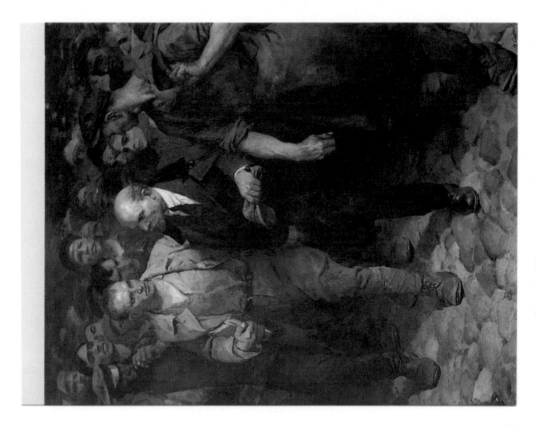

21. В. И. Ленин беседует с лесорубами

«Изобразительное искусство». Москва
© Художник Н. А. СЫСОЕВ. 1990
4-027. 2994. 40 000. 4 к.
ОТПРАВЛЯТЬ ПО ПОЧТЕ ТОЛЬКО В КОНВЕРТЕ

V. I. Lenin talks with woodcutters

This painting by N.A. Sysoev is carefully composed to show Lenin as the mentor and teacher of ordinary citizens, in this case a group of woodcutters in the forest. He is depicted as being on the same level as them, and is thus a man of the people, but at the same time he is clearly at the centre of the group and is holding the attention of the workers as he explains some tenet of Marxist-Leninist thought.

Lenin may never actually have addressed workers in a forest in this way, but the painting is intended to show the 'poetic truth' of the Bolshevik Revolution and of Communist society, where the leaders identify themselves with the people, and guide them to the utopia to come.

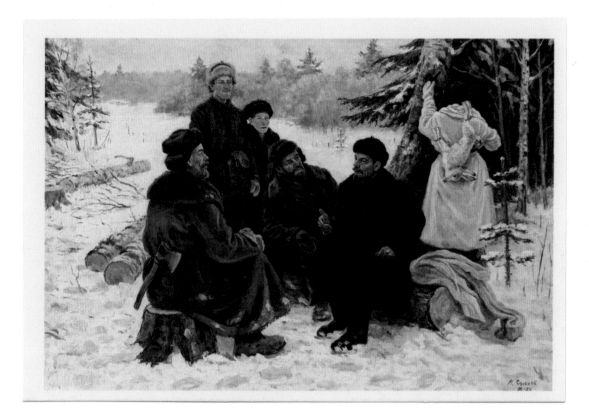

23. В день рождения

«Изобразительное искусство». Москва
С. Худяшова Н. А. СЫСОЕВ. 1990
т-8257. 2396. 60 000. 4 к.
ОТПРАВЛЯТЬ ПО ПОЧТЕ ТОЛЬКО В КОНВЕРТЕ

On his birthday

Another painting by N. A. Sysoev, which shows Lenin walking in the woods with his wife Krupskaya and his older sister Anna, who was also an active revolutionary. The intention is to show a happy family group (although it can hardly be said that Krupskaya looks very cheerful), and a leader in whom the people can have confidence that he is at heart just like them, whilst also possessing the wisdom to lead them forward into the future.

Although Lenin himself was supposed to deplore anything smacking of the 'cult of personality', it is striking that throughout the Soviet era artists consistently portrayed him as the icon of the new orthodoxy, who was beyond any kind of criticism. This was a trend Stalin was to perpetuate and take to new extremes.

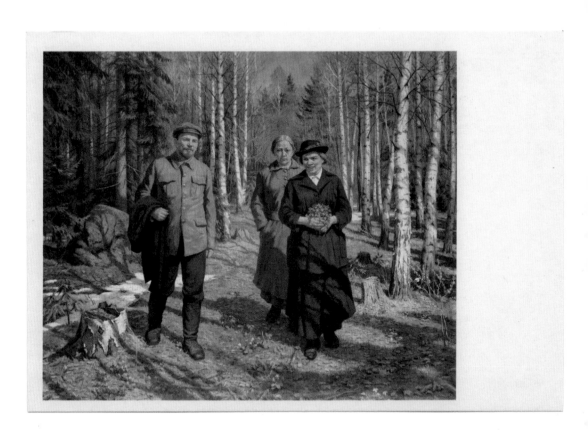

МК МЕЖДУНАРОДНАЯ КНИГА

В первые годы Советской власти в нашей стране только закладывался фундамент социалистического общества, только пробивались первые ростки коммунизма. Но Ленину, как никому другому, было присуще чувство нового. Он увидел эти ростки в массовых субботниках трудящихся. Первый субботник состоялся 10 мая 1919 года на Московско-Казанской железной дороге. После окончания смены рабочие безвозмездно ремонтировали паровозы и вагоны, разгружали прибывшие на станцию грузы. Вскоре субботники стали проводиться по всей стране. Они были ответом рабочего класса на призыв Центрального Комитета партии, выражением его беззаветной преданности идеям Октября. В одном из субботников, состоявшемся 1 мая 1920 года, принимал непосредственное участие В.И. Ленин. Опыт первых субботников проанализировал, теоретически его обобщил и дал ему политическую оценку В.И. Ленин в работе „**Великий почин**".

Пролетариат, разъяснял в ней Ленин, представляет и осуществляет более высокий тип общественной организации труда по сравнению с капитализмом. „Коммунистическая организация общественного труда, к которой первым шагом является социализм, держится и чем дальше, тем больше будет держаться на свободной и сознательной дисциплине самих трудящихся, свергнувших иго как помещиков, так и капиталистов". Гигантское значение субботников Ленин видел прежде всего в том, что они означали переворот более трудный, более существенный, более коренной, более решающий, чем свержение эксплуататоров, ибо это – победа над собственной косностью, распущенностью, мелкобуржуазным эгоизмом, над всем, что капитализм оставил в наследство рабочему и крестьянину. В связи с субботниками Ленин раскрыл сущность коммунистического труда, показав его отличие от характера труда при социализме, который он характеризовал как первую фазу формирования коммунистического общества.

Иванов В. В.И. Ленин на субботнике в Кремле

Lenin at subbotnik in the Kremlin

Subbotniks were days of voluntary unpaid labour on community projects, and this painting by V. Ivanov shows Lenin participating in the first all-Russia subbotnik on May Day, 1920, when he helped clear building rubble in the Kremlin. Lenin was enthusiastic about the idea of subbotniks, seeing them as the precursor of free labour under Communism, but they were much less popular with the workers, who resented having to give up their free time during weekends to participate in them. The caption on the back of the card reads:

In the first years of Soviet power the base of a socialist society was being laid and the first 'shoots' of Communism were beginning to appear. Lenin saw these 'shoots' in mass Communist subbotniks. The first was held on 10 May, 1919, when workers of the Moscow–Kazan Railway voluntarily repaired steam locomotives and carriages and unloaded goods after their labour shift. V. I. Lenin took part in the subbotnik of 1 May, 1920. Lenin analysed the experience of the first subbotniks and gave them a political appraisal in his work 'Great Initiative'. Lenin considered that Communist subbotniks were more difficult, significant, and decisive than the overthrow of bourgeois power because they meant victory over one's own stagnation, lack of discipline, and petty-bourgeois selfishness.

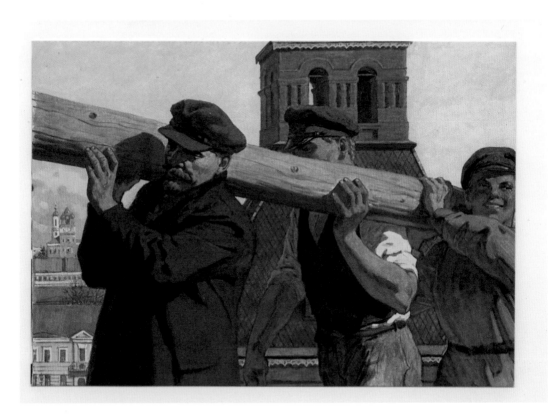

*1. Мария Александровна Ульянова читает сказки
своим детям Володе и Оле*

*«Изобразительное искусство». Москва
© Художник Н. А. СЫСОЕВ. 1990
4-427. 2354. 60 000. 4 к.*

ОТПРАВЛЯТЬ ПО ПОЧТЕ ТОЛЬКО В КОНВЕРТЕ

Maria Alexandrovna Ulyanova reads Russian fairy stories to her children Volodya and Olya

This painting by N.A. Sysoev in socialist realist style depicts Lenin's mother reading to the young Vladimir and his sister Olga, who was to die tragically young at the age of nineteen whilst a university student. The intention is to show a model household in which the children are well-behaved and attentive, whilst the mother acts as a teacher and educator.

Maria Alexandrovna Ulyanova (1835–1916) had in fact trained as an elementary school teacher, although she spent the greater part of her adult life supporting her family of revolutionaries. Her father, Israel Blank, was a Jewish convert to Christianity, whilst through her mother she had German and Swedish ancestry. She studied Russian and western literature for an external degree and could read German, French, and English as well as Russian.

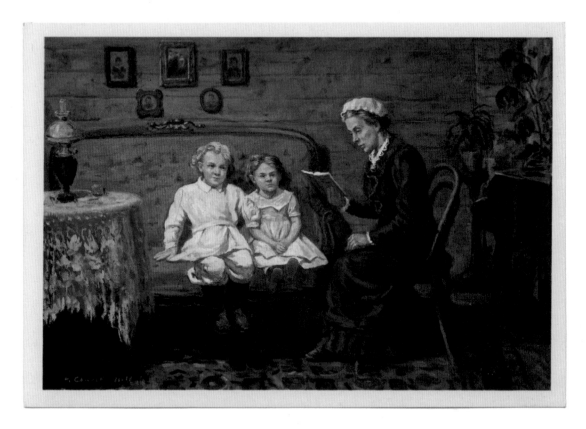

Stalingrad Tractor Factory, 1931

The tractor was the symbol of agricultural mechanization and of economic modernization more generally throughout the Soviet period, and the Stalingrad Tractor Factory was a showpiece of industrial development in the Soviet Union. It was established in 1930 and by 1940 had produced over 200,000 tractors. During the Second World War it was converted to tank production and produced the famous T-34 tank which made a major contribution to the Soviet Union's victory over Nazi Germany; one is still displayed at the entrance to the factory today.

After the war, the factory returned to tractor production and in all built around 2.5 million tractors during the Soviet period. Now known as the Volgograd Tractor Factory, it is still in existence.

This card is a reproduction of a 1934 painting by Vasili S. Svarog (1883–1946), a leading exponent of socialist realist art.

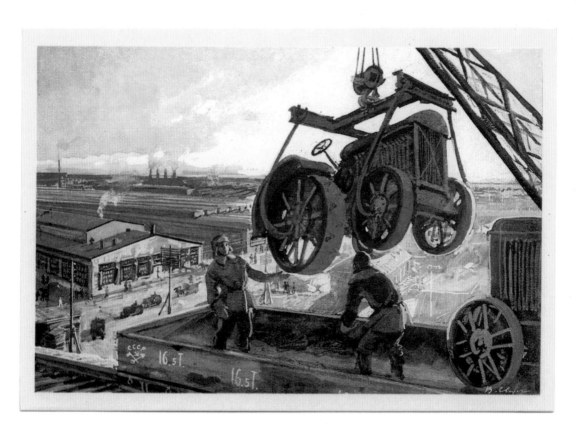

21

Stalin

Very few portraits of Stalin were painted from life; instead idealized pictures were produced, creating an image of the wise and confident leader whom the people could trust and look up to. This card depicts a relatively youthful Stalin, brimming with health and looking forward confidently, with no hint of doubt, into a future of no time and no place—the Communist utopia to come. The lack of a background suggests the universality of his appeal, whilst the appearance of the flag as the only object depicted suggests his total dedication to the cause. It is also worthy of note that he is wearing a simple jacket, without any orders or decorations, suggesting an innate modesty and identification with ordinary people, a propaganda device that was also employed by Hitler, although not by the more bombastic, but less powerful, Mussolini.

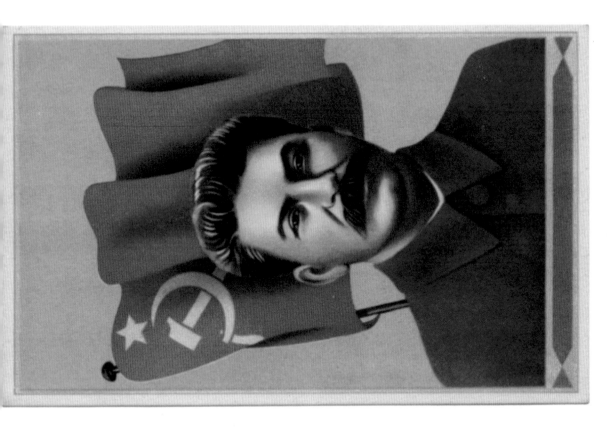

23

At the Party's call

This card dates from 1954 and reproduces a propaganda poster designed to inspire farm workers and others to join Khrushchev's Virgin Lands Campaign. The aim of this campaign was to open up vast tracts of previously unseeded 'virgin land' in the steppes of Kazakhstan for grain production and so make the Soviet Union self-sufficient in food supply. It was also intended to surpass American grain production and thereby demonstrate the superiority of the Soviet system over capitalism. More than 300,000 people answered the call and the experiment was for a brief time successful before ending in almost total failure, a factor that later led to Khrushchev's fall from power.

The designer of this card was Alexei Kokorekin, who was well-known as the designer of many wartime propaganda posters. The heroic resolve displayed by these tractor drivers suggests that the campaign could be viewed as a new war to secure the future of the Soviet state.

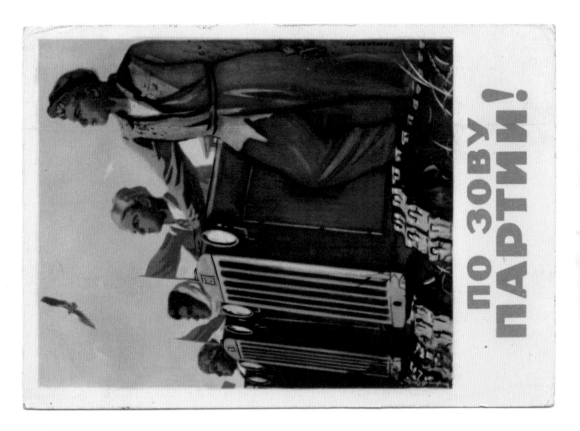

ПО ЗОВУ ПАРТИИ!

25

Happy May Day

1 May has been regarded as an international Labour Day since the nineteenth century. Although the idea originated in Australia, and possibly derived from the fact that 1 May was the feast of St Philip and St James, the patron saints of workers, in the twentieth century it became more explicitly associated with left-wing movements. In the Soviet Union it was a public holiday and the occasion of a big public parade through Red Square in Moscow in front of the Soviet leaders, who watched from the balcony on Lenin's mausoleum. The event was carefully choreographed to portray a society in which peace and harmony ruled, however different the reality may have been.

This design by A. I. Shmidshtein reflects this view of May Day as a joyous occasion for workers in the Soviet utopia.

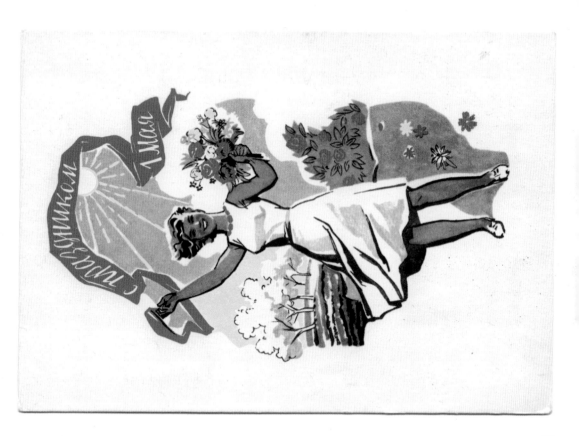

С праздником!

1 Мая

27

Friendship of the nations

This remarkable design by the socialist realist artist Stepan Karpov (1890–1930), best known for his portrait of Lenin, reflects the confident belief of the early Soviet Union that it had destroyed the old world (symbolized by the war-ravaged ruins glimpsed through the arch on the left) and had broken through into a new world of peace, prosperity, and progress. The victorious workers and peasants hold aloft the symbols of the new order, the hammer and sickle, a plough and cog wheel, a full wheat sheaf, and an open book—a reference to the guidance provided by the works of Marx, Engels, and Lenin. As in so much Soviet iconography, they face into the wind,

symbolizing the further difficulties they will have to overcome, and look towards the rising sun, harbinger of the better future to come. In the background peaceful fields and an aeroplane show two aspects of what that future could be. The field gun indicates that they have had to fight to obtain their victory, and, since it is facing forward, perhaps also indicates a resolve to deal equally resolutely with any future enemies.

Both the title of the card and the ethnic mix of the people portrayed on it refer to the early Soviet Union's determination to retain control of all the lands of the former Russian Empire, even when many of the minorities wished to break away. The fiction that the Soviet Union was a free association of many different nationalities united in a desire to build a socialist future was maintained almost to the end of the Communist era.

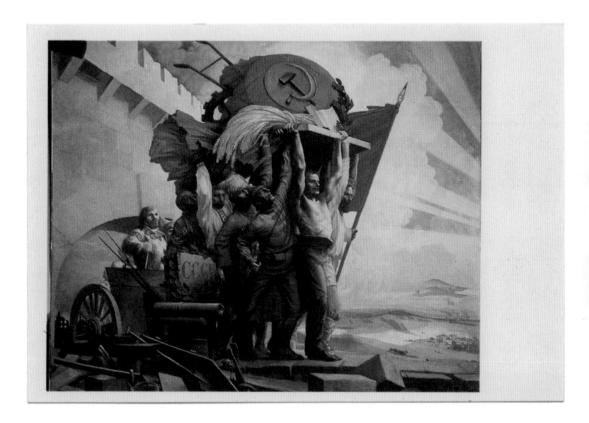

9 May—on Victory Day

The Soviet Communist Party acquired great prestige through leading Russia to victory in the Second World War (always known in Russia as the Great Patriotic War). By harnessing simple patriotism to party ideology, the Party enhanced its legitimacy as the ruler of the Soviet Union, and subsequently it did much to keep the war and Russia's victory in it in the forefront of public memory. 9 May—Victory Day in Europe—became a public holiday and remains so in Russia today.

This card, designed by A. Minenkov, depicts a more tangible memorial of the war, the giant statue representing the Motherland calling on her sons to fight the enemy which was erected in Volgograd in 1967. The 85m-high statue particularly commemorates the battle of Stalingrad (as Volgograd was then known), which marked the turning point of the war and in which around half a million Soviet citizens, military and civilian, lost their lives.

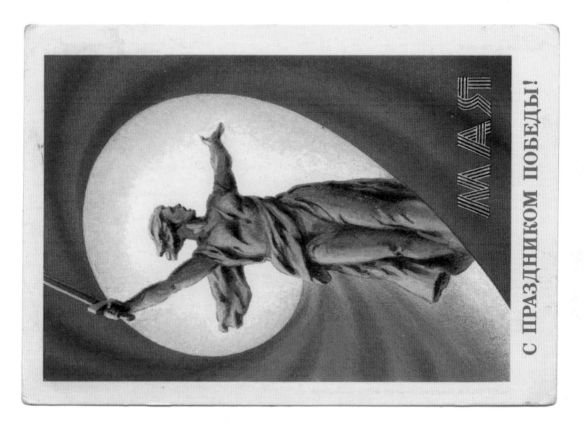

МАЙ

С ПРАЗДНИКОМ ПОБЕДЫ!

С дружеским
приветом
всей семейству
Новотных!
Ева, напиши нес-
колько строк о
своей жизни.
Как здоровье
родных?
Какие новости?

ЗДРАВСТВУЙ, СОЛНЦЕ!
Художник Е. Соловьев. В. Сер...

Ш0107)-59. 3—737. Т. 850 000. Ц. 20 к. 3. 75.
...г. Калинин.

Цена — р.0.2.к.

2 January 1959—Hello Sun

This colourful and attractive card was produced to mark the launch of Luna I (or First Cosmic Rocket as it was originally known) by the Soviet Union in 1959. Luna I was the first object to reach the escape velocity of Earth and the mission was also responsible for the discovery of solar wind. It was originally intended that Luna I would crash into the moon, delivering a Soviet flag in the process, but in the event the rocket missed the moon by just under 6,000km and subsequently became the first man-made object to go into orbit around the sun.

In this early period of space exploration the Soviet Union often appeared to be ahead of the Americans, and the Soviet space programme was used to indicate the technological advantage the socialist states had over the capitalist states of the West. Just as tractors had done in the past, so space rockets were now used to symbolize modernity and technological advance, the implication being that the future lay with the Communist system that had produced them.

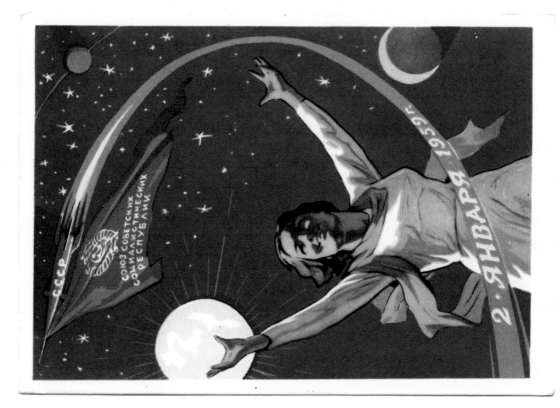

33

Dux

The image of the leader as a resolute military strongman
is one that is common to all totalitarian regimes,
whatever their political orientation. Here Mussolini
adopts the pose, but underneath he was well aware of
Italy's military weakness and was careful not to enter the
Second World War until, mistakenly, he thought it was
already won by Germany.

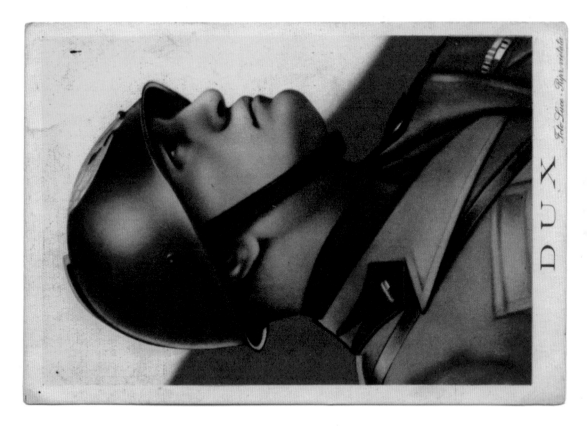

DUX

Foto Luce - Riprodotta

35

Fanciulli, voi dovrete essere i custodi fedeli per tutta la vita della nuova eroica civiltà, che l' Italia sta creando nel lavoro, nella disciplina, nella concordia.

MUSSOLINI

Ed. d'Arte V. E. Boeri - Via F. Corridoni 7 - Roma

You young boys, throughout your life, should be faithful custodians of the new heroic civilization that Italy is creating in the workplace, in matters of discipline and in peaceful times

The co-option of youth into the service of the state was a common feature of all the utopian regimes. Here Mussolini receives a bouquet of flowers from children grateful for his wise guidance, whilst the caption on the back exhorts them to participate in the march towards a heroic future, a reference to the new 'Roman Empire' that Mussolini believed should be Italy's destiny. The emphasis on work and discipline was also common to all the Fascist regimes, as was the reference to peace (whilst actively preparing for war).

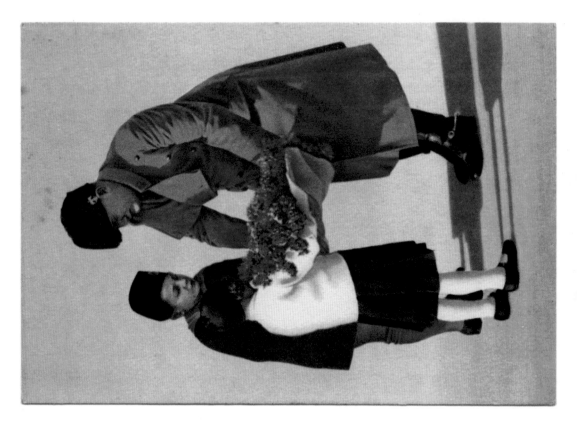

SCUOLA ALLIEVI UFFICIALI DI ARTIGLIERIA - BRA

Rag. F. DUVAL - EDITORE - MILANO
Via S. Bonaventura N. 27

Believe, obey, fight

This Italian card was produced by the Artillery Training School, and depicts three muscular soldiers marching forward to victory by following these three straightforward maxims. The design links Fascist images with those of the Italian monarchy, to which many of the soldiers may have felt a greater loyalty.

During the Second World War, many of the Italian forces showed considerably less resolve than the idealized figures depicted here, suggesting that Fascist ideology never had very deep roots in the country.

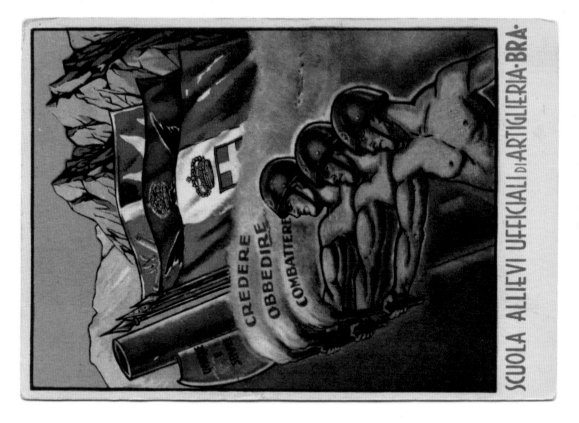

CREDERE
OBBEDIRE
COMBATTERE

SCUOLA ALLIEVI UFFICIALI DI ARTIGLIERIA·BRA·

The Italian woman, with her renunciation and her sacrifice, marches in step with the combatants

This striking image, designed by Gino Boccasile (1901–1952), dates from the Second World War, when the Fascist government of Italy realized that it was important to maintain morale on the home front and to engage Italian women in the struggle for victory.

Through their sacrifice and renunciation of peace-time comforts, they can help their menfolk march to glory. This figure of heroic womanhood has been popular with all revolutionary and utopian regimes from the French Revolution onwards.

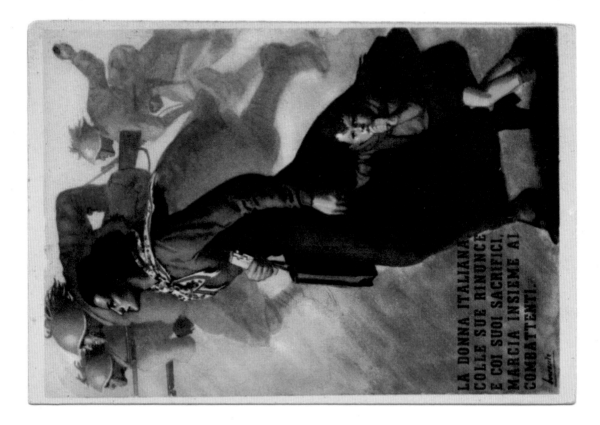

LA DONNA ITALIANA
COLLE SUE RINUNCE
E COI SUOI SACRIFICI,
MARCIA INSIEME AI
COMBATTENTI.

41

Fervent rotae, fervent animi

The title of this card was the motto of the Italian Military Driving Corps, and can loosely be translated as 'Wheels and souls moving together'. A convoy is shown speeding purposefully into combat despite being under fire. The intention was to show both the resolve of the Italian army and the up-to-date nature of its equipment. However, during the Second World War, both failed to live up to this idealized image. The artist

was Manlio D'Ercoli, who was responsible for a number of propaganda postcards during the war.

The appearance of Vesuvius in the background is probably a result of the card being produced in Naples, although whether the intention was to show the corps rushing to the defence of the city is unclear.

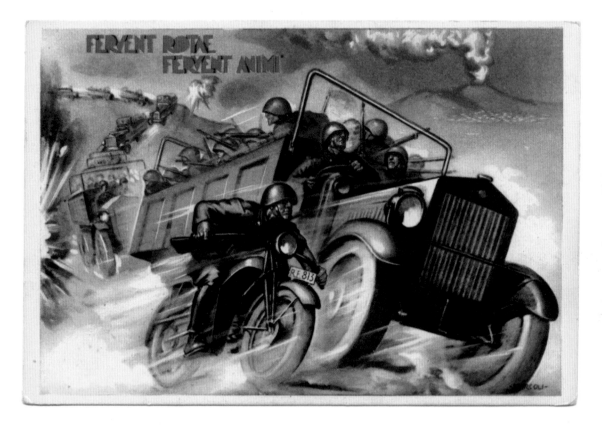

43

Work, freedom, and bread. Vote National Socialist—List 8

This Nazi election poster dates from 1928 and depicts a middle-aged agricultural worker sowing seed by hand. The slogan is strikingly similar to those used by Lenin's Bolsheviks to gain power in Russia eleven years earlier.

The Nazis were keen to appeal to agricultural workers and small farmers, and the image on this poster with its depiction of an already anachronistic method of sowing, seems designed to appeal to their independence and conservatism. After they gained power, the Nazis attempted to introduce policies that would make Germany self-sufficient in cereals; this resulted in greater production of ryebread at the expense of wheat.

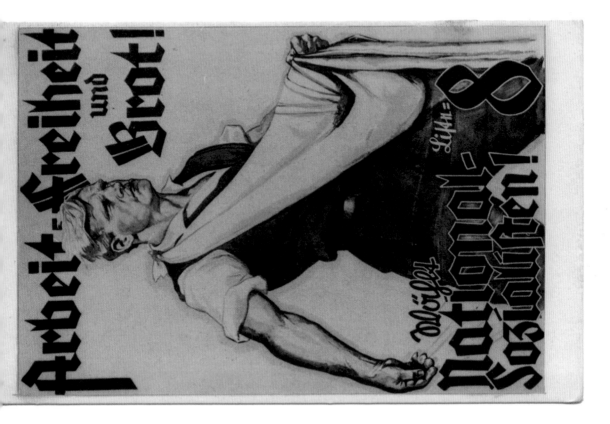

45

The Banner Carrier

This postcard was published by Heinrich Hoffman, Hitler's official photographer, who claimed in his memoirs that it was very popular and sold in 'millions'. The original painting was in the second exhibition of German art (1938) which Hoffman curated under the guidance of Hitler—and for which Hoffman had the postcard concession.

Hitler's words read:

> Whether it was good times or bad times, whether while at liberty or in prison, I always stayed loyal to my flag, which is now the official flag of the German Reich.

Both the words and the image link Hitler to Germany's past. Depicted as a Teutonic Knight, he is shown as a crusader for German culture against the forces of barbarism to the east, whilst the references to the Nazi flag and the Reich are carefully crafted to draw ordinary German patriotism into the service of the Party.

DER BANNERTRÄGER

„Ob im Glück oder im Unglück, ob in der
Freiheit oder im Gefängnis, ich bin meiner
Fahne, die heute des Deutschen Reiches
Staatsflagge ist, treu geblieben."

Adolf Hitler

And you have won after all!

This 'official memory postcard' was posted in Munich on 9 November 1938, and it thus commemorates the failed Beer Hall Putsch of 9 November 1923 when Hitler first attempted to seize power. Once the Nazis came to power in 1933, each year they held a major commemoration on the anniversary of the putsch. The bodies of the sixteen members of the Party who died in the uprising were re-interred in two Ehrentempel (Honour Temples), which became a major shrine to Nazism.

The message of the card is that the forces of Nazism were unstoppable and could look forward confidently as the face of the future. At the time this card was sent, Hitler's triumph in negotiating the Munich Agreement with Britain and France, paving the way for the dismemberment of Czechoslovakia, was less than two months old, and his popularity in Germany was at its height. Only a minority of Germans would have disagreed with the sentiments of this card at that time.

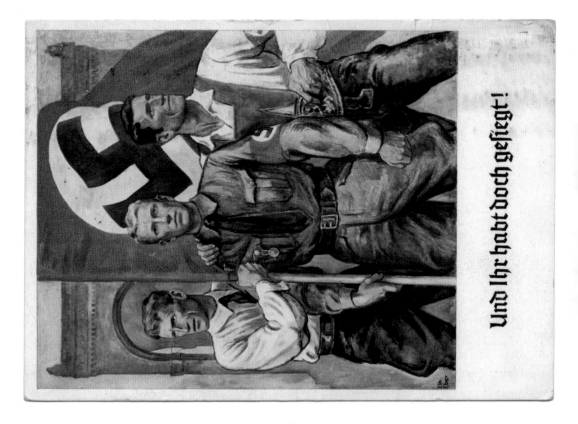

Und Ihr habt doch gesiegt!

49

POSTKARTE

Highland Area, First Regional Meeting in Munich, 19–21 August

This striking image of a drummer boy of the Hitler Youth is a graphic depiction of the militarization of youth under the Nazi government of Germany. Such a glamorous image was well calculated to attract greater numbers into the movement, especially in such regions as Bavaria, where the Nazis were opposed by many existing Catholic youth organizations.

The Hitler Youth appealed to many through its promotion of activities such as camping or excursions, but its primary role was to indoctrinate young people (girls as well as boys) with national socialist ideology. It was founded in 1926 but at first its growth was slow. In 1932 there were only some 2,000 members in Bavaria, but by 1936, three years after the seizure of power by the Nazis, it had risen to 625,000 and numbers reached one million the following year.

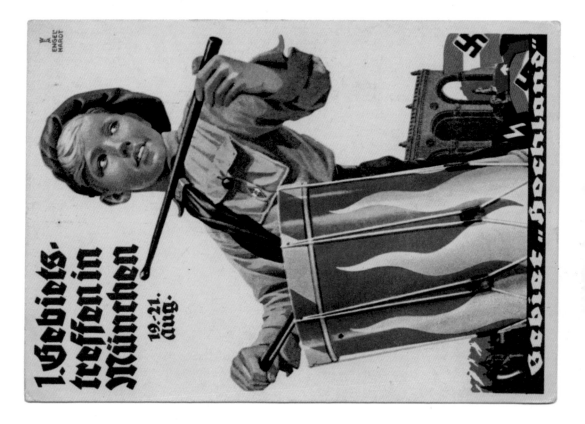

Nordland Forlag Postboks 7916
DK 9210 Aalborg Denmark

Officer of tomorrow

The militarization of youth in the service of the state was an important feature of all totalitarian regimes. In this famous Nazi propaganda card the transition from Hitler Youth to the army is shown as both admirable in itself and as something which was entirely natural.

That the soldier, although relatively youthful, has already won two Iron Crosses, a Knight's Cross, and an Infantry Assault Badge was intended to show members of the Hitler Youth that they too in time could be decorated for valour in the service of their country.

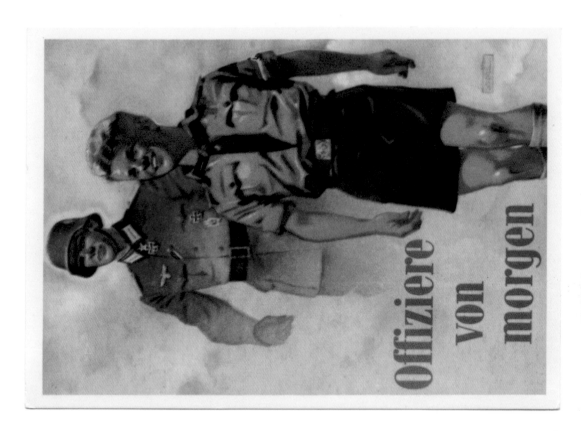

Offiziere von morgen

53

National Party Congress, Nuremberg, 1937

Officially called the 'Reichsparteitag des Deutschen Volkes', or National Party Congress of the German People, the Nuremberg rallies of the 1930s were spectacular propaganda events, whose aim was to demonstrate the power and invincibility of the Nazi Party and to symbolize the solidarity between the Party and the people. The monumental architecture of the stadium in which the rallies were held was also deliberately designed to overawe and impress.

The 1937 Party Congress was also called the 'Rally of Labour' and had as its principal theme a celebration of the reduction of unemployment through Nazi policies in Germany. One particularly striking feature of the rally, depicted on this card, was the so-called 'Cathedral of Light', created by 152 searchlights sending a powerful beam of light into the sky, and, in this representation, illuminating the Nazi emblem as a beacon for the present and the future.

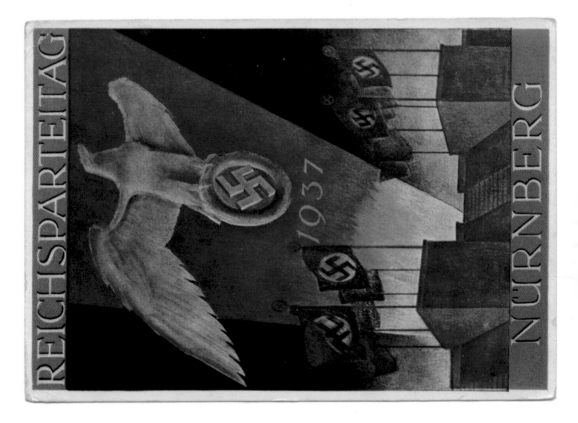

FERDINAND STAEGER
»WIR·SIND·DIE·WERKSOLDATEN . . .«
Ludwig-Siebert-Festhalle Bayreuth
We are the work soldiers
Nach dem farbigen Hanfstaengl-Druck 90×72 cm

Franz Hanfstaengl, München, Printed in Germany

Hanfstaengl-Künstlerpostkarte Nr 172.

We are the work soldiers

By depicting soldiers carrying spades, this card aimed to show that the army and the people were working in harmony to build the future through public works. The fusion of the military and the civilian population, and the militarization of the latter are common features of utopian regimes.

The designer of this card, Ferdinand Staeger (1880–1976), was a well-known German artist (although born in Moravia). He was a war artist during the First World War and later became known as a painter of mystical or mythological scenes.

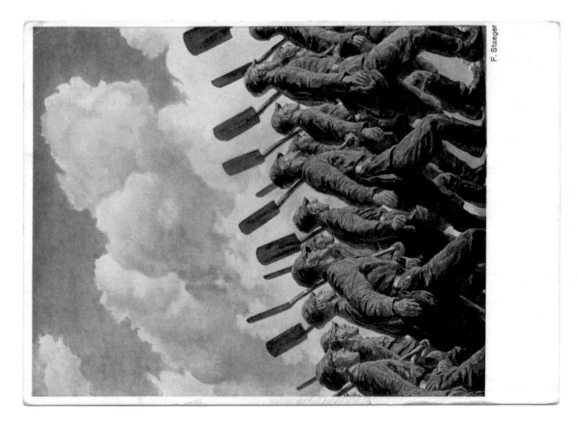

F. Staeger

Neighbourhood

'Siedlungen' or 'neighbourhoods' were an important tool whereby the Nazis sought to win the support of the working classes. Created under the umbrella of the National Socialist organization 'Strength through Joy' ('Kraft durch Freude'), they were model settlements, whose houses were allocated only to members of the Nazi Party who had a certificate to say they were 'racially pure'. The uniform character of the houses in each settlement, or 'neighbourhood', was intended to create a feeling of unity amongst the inhabitants, whilst they were also designed to reflect the idea of the Heimat or homeland. Each house was detached and had its own garden, which was intended not just to create a garden-city effect, but to enable the inhabitants to grow vegetables and become self-sufficient in case of war.

During the 1930s thousands of these houses were built, their construction also helping to reduce unemployment. In spite of their association with Nazi ideology, they remain very popular today.

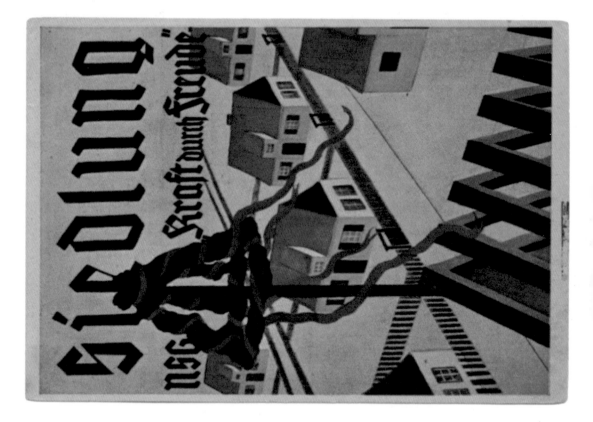

59

TARJETA POSTAL

Help the anti-Fascists from the revolutionary field

During the 1930s, the Spanish Civil War was seen worldwide as a struggle between two competing utopian visions of the future, and thousands from overseas volunteered to fight for the Republican government against the forces of Fascism, led by General Franco. This card represents an appeal by the Solidaridad Internacional Antifascista for others to join the fight. The winged figure of peace and progress grieves over the victims of Fascism being led into slavery by the sinister figure of a black knight. The latter refers to the militarism associated with Franco's forces, and perhaps also to the fact that Franco associated himself with El Cid and the supposed glories of medieval Spain.

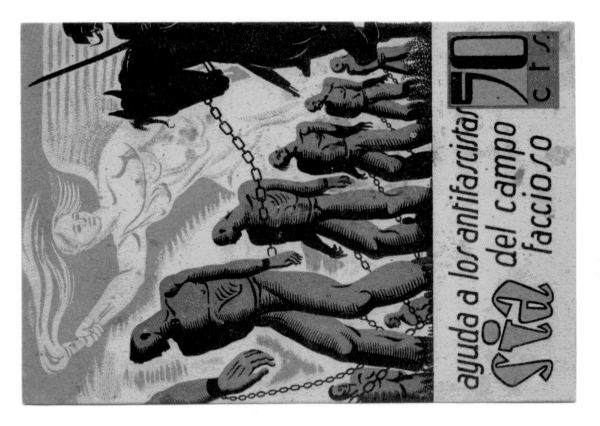

ayuda a los antifascistas del campo faccioso

SIA

70 cts.

For the brothers at the front: Women! Work!

This card from the Spanish Civil War is in Catalan and was produced jointly by the Partido Socialista Unificado and the Union General de Trabajadores in Barcelona in 1936. Its purpose was to inspire the women on the home front to identify with their menfolk fighting the forces of Fascism. The pose of the woman on this card is strikingly less heroic than on the similar Italian card included in this collection, but the message is broadly similar—that by devotion to the cause, in this case by knitting warm woollen garments to see the troops through the winter months in the trenches, the women at home can play their part in ensuring ultimate victory.

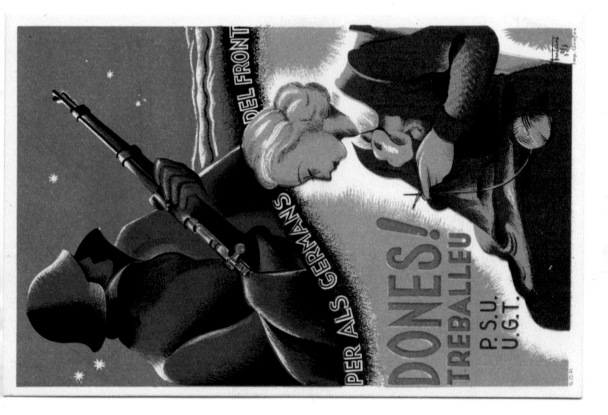

DEL FRONT

PER ALS GERMANS

DONES!
TREBALLEU
P.S.U.
U.G.T.

Erdély

This card was produced to commemorate the re-annexation of northern Transylvania by Hungary in September 1940, and was posted from the Transylvanian capital, Kolozsvár (now Cluj), only two days after the re-annexation process was completed. The caption on the back reads:

> Brothers, we have arrived; we bring our hearts but if necessary we can shed blood for Transylvania.

Transylvania had formed part of the Austro-Hungarian Empire until the end of the First World War, when under the terms of the Treaty of Trianon it became part of Romania. The area within Transylvania known as Erdély to Hungarians and Ardeal to Romanians has been a source of contention between the two countries ever since.

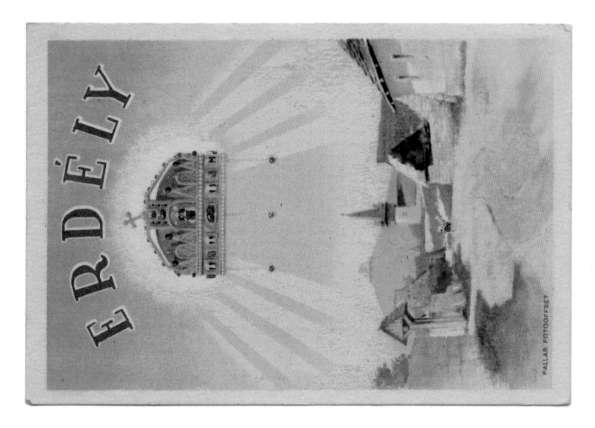

ERDÉLY

PALLAS FOTOOFFSET

May 1945

This Czechoslovak card was produced at the end of the Second World War and depicts the liberation of their country from Nazi occupation as being an equal partnership between their own forces and those of the Soviet Union. The implication is that the alliance between Czechoslovakia and the Soviet Union will lead the way to the rebuilding of the country and to future prosperity.

The President of the Czech government in exile, Edward Beneš (pictured on the right), had signed an agreement with Stalin, and he was formally re-elected as President in 1946. At first the government consisted of a coalition, but in February 1948 the Communists under Klement Gottwald seized complete power. Beneš resigned in June 1948 and died three months later.

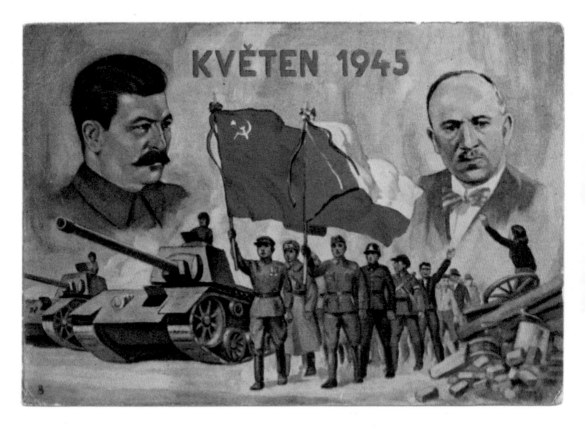

KVĚTEN 1945

67

9 May 1945

In this card a Czechoslovak girl falls on her knees to thank a Soviet soldier for liberating her country (Prague Castle can be seen in the background). Both of them are standing on a ripped and torn Nazi flag, graphically illustrating the sudden change in the dominant ideology of the country following the liberation.

This image of the liberation of Eastern Europe by the Red Army remained a powerful and evocative one, but in 1968 Soviet troops again entered Czechoslovakia, to crush the 'Prague Spring', and on this occasion they were not greeted as liberators. As a result, the image of Communism as a progressive force suffered a blow from which it never recovered.

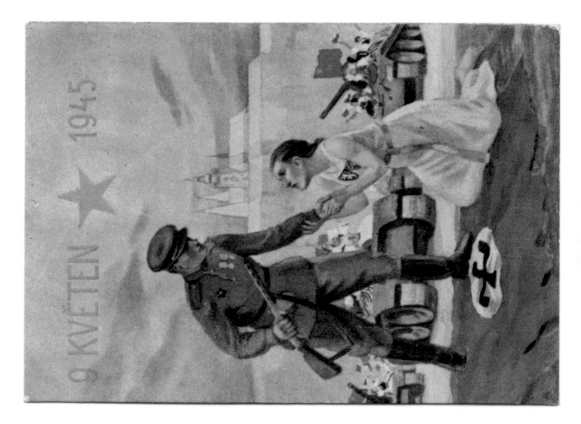

The Balkan Games, the partisan march

Totalitarian regimes have a long history of using sport as a political tool. This Albanian card was produced to commemorate the unofficial Balkan Games which were held in Tirana in 1946, and which included such unusual events as grenade throwing and the 'partisans march'. The flags are those of the countries which took part in the Games, Yugoslavia, Albania, Bulgaria, and Romania; in the first two of these at least Communist partisans had been largely instrumental in leading the resistance to Nazi or Fascist rule and occupation, and all had recently established Communist governments.

The Balkan Games were first held in 1929 and were officially sanctioned in 1930. They were held on an annual basis until 1940 and were then re-established in 1953. The Games held in Tirana in 1946 were unofficial and were dominated by Yugoslav and Romanian athletes, with Albania failing to win a single event.

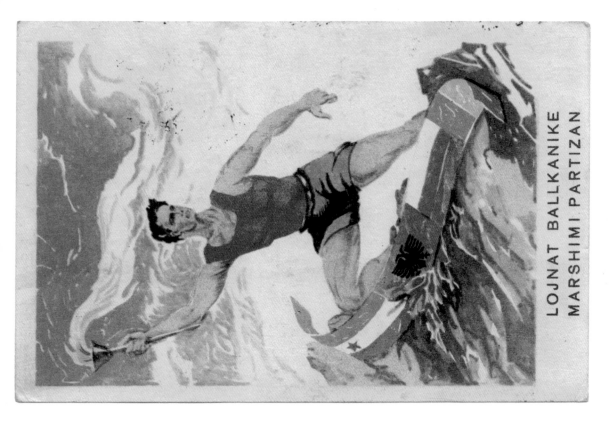

LOJNAT BALLKANIKE
MARSHIMI PARTIZAN

71

World youth fight for peace

This Czechoslovak card was produced to commemorate the World Festival of Youth and Students, which has been held on sixteen occasions since the Second World War, the first being in Prague in 1947 when 17,000 participants from seventy-one countries attended. The Festival is jointly organized by the World Federation of Democratic Youth (WFDY), founded in London in 1945, and the International Union of Students. Originally intended to represent youth worldwide, by the 1960s it had come to be seen as a 'front' organization for the Communist parties of Eastern Europe and as a successor to the Young Communist International.

From the beginning the WFDY described itself as 'anti-imperialist', and the design of this card is clearly intended to show the support of the Festival to Asian and African youth who were then fighting for independence and liberation from colonial rule. During the Cold War, its anti-imperialist stance gained the Soviet Union many friends and supporters in the Third World.

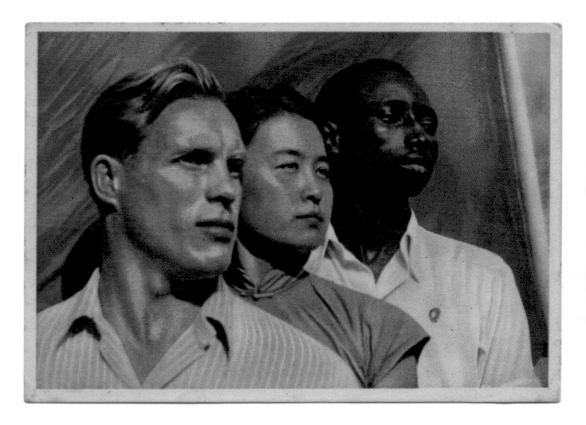

73

Jan Čumpelik:
SE SOVĚTSKÝM SVAZEM NA VĚČNÉ ČASY.
Plakát 1950.

ORBIS

D 174

£12—

With the Soviet Union for ever

Following the establishment of socialist 'people's republics' in the countries of Central and Eastern Europe after the Second World War, it became an article of faith that the Soviet model had to be slavishly followed in every respect and that there was total unity of opinion between the governments and peoples of the Soviet bloc. 'With the Soviet Union for ever' was a well-known slogan of the time.

This Czech card, dating from 1950, expresses this sentiment by showing a partisan and a Soviet soldier fraternally looking forward, confident in the knowledge that their common victory in the Second World War, symbolized by the sprig of laurel above them, is merely a harbinger of future victories to come. The use of the Czech national colours at the bottom of the card is intended to unite national patriotism to the cause of solidarity with the Soviet liberators.

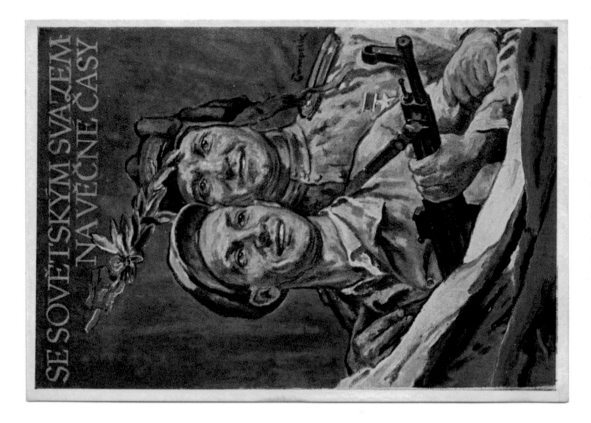

Alena Čermáková:
ZA MÍR, ZA VLAST, ZA SOCIALISMUS.
Plakát 1950.

ORBIS

D 177

£12

For peace, country, and socialism

Since Lenin first coined the slogan 'Peace and bread', Communist parties have sought to link a desire for peace and love of one's country with socialism; wars are by definition 'capitalist wars', whilst peace and prosperity can only be achieved through unity in striving for the socialist, or Communist, ideal.

This Czechoslovak card dates from 1950 and depicts a couple marching forward cheerfully to express their solidarity with these seemingly straightforward aims. It is significant that they are marching under not only a host of red flags but also the Czech national flag. The conscription of national symbols to serve the Communist cause was a notable feature of all the socialist countries of Eastern Europe.

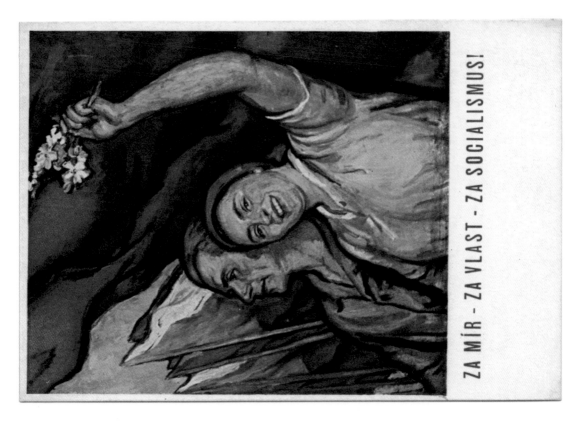

ZA MÍR – ZA VLAST – ZA SOCIALISMUS!

Czeglédi - Bánhegyi: Előre a béke és a szocializmus ifjú
harcosainak kongresszusáért - Az egybeolvasztott
ifjúsági szervezetek első közös kongresszusának
plakátja, 1950
Czeglédi - Bánhegyi: Forward for the Congress of the
Young Fighters of Peace and Socialism! - poster of the
first congress of merged youth organizations, 1950
Magyar Nemzeti Múzeum (Hungarian National Museum)

COPYART KFT. Tel.: 215-6092

Fotó: Dabasi András

Prosperity springs from socialist production

This later postcard reproduces a poster from the time of the Hungarian Soviet Republic of 1919. The linking of increasing material prosperity for workers' families (here seen in the background) with greater industrialization and the adoption of socialist means of production was a common theme of early Bolshevik propaganda.

The Commune, under the leadership of Béla Kun, lasted for only 133 days. The so-called 'Red Terror' of this period left bitter memories that contributed both to the rise of the extreme right and to increasingly anti-Semitic policies in Hungary, which reached their apogee during the Second World War. Following the Communist seizure of power in Hungary after the Second World War, the Commune came to be depicted as an heroic precursor of their own regime, and references to the darker aspects of the 'Red Terror' were replaced by similar references to the succeeding 'White Terror' of the Horthy period.

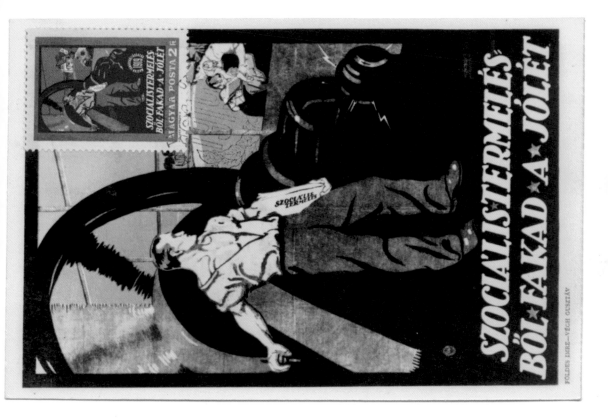

Czeglédi - Bánhegyi: Előre a béke és a szocializmus ifjú
harcosainak kongresszusáért - Az egybeolvasztott
ifjúsági szervezetek első közös kongresszusának
plakátja, 1950
Czeglédi - Bánhegyi: Forward for the Congress of the
Young Fighters of Peace and Socialism! - poster of the
first congress of merged youth organizations, 1950
Magyar Nemzeti Múzeum (Hungarian National Museum)

COPYART KFT. Tel.: 215-6092

Fotó: Dabasi András

Forward for the Congress of the Young Fighters of Peace and Socialism

This Hungarian card reproduces a poster for the
Congress, which was held in June 1950. The Hungarian
Communist leader, Mátyás Rákosi, who revelled in the
title 'Stalin's best pupil', points the way forward, whilst
figures representing workers, peasants, and intellectuals
follow his gaze in looking eagerly towards the utopian
socialist future. The initials DISZ on one of the banners
stand for Dolgozó Ifjúság Szövetsége (Association of
Working Youth), the Communist youth organization, to
which it was compulsory to belong.

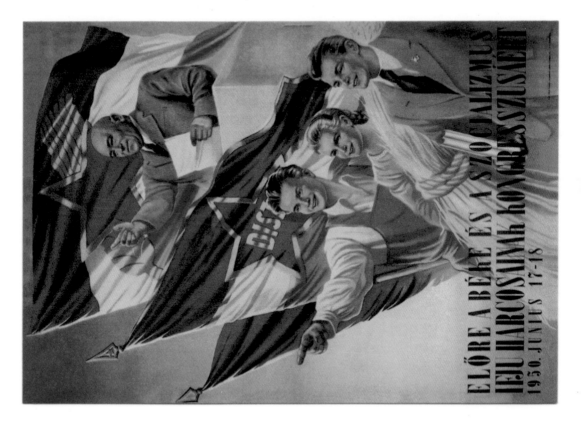

ELŐRE A BÉKÉÉRT ÉS A SZOCIALIZMUS
IFJÚ HARCOSAINAK KONGRESSZUSÁÉRT
1950. JÚNIUS 17–18

М. И. САМСОНОВ (Род. 1925 г.)
Боец Народной армии Вьетнама

A soldier of the people's army of Vietnam

This Russian card dates from the period of the Vietnam War, when the Soviet government supported the Communist government of North Vietnam against the American-backed forces of South Vietnam. The war was seen as an anti-imperialist struggle, and this image of a North Vietnamese soldier is intended to convey the calm, and even cheerful, resolution of a member of a citizen army seeking to liberate his country from the capitalist and imperialist American invaders, whilst the bird on his shoulder suggests that he and his cause are in harmony with the natural world around them—a far cry from the actuality of the war.

Both this and the following card were designed by M. I. Samsonov, who was an official artist of the Soviet army.

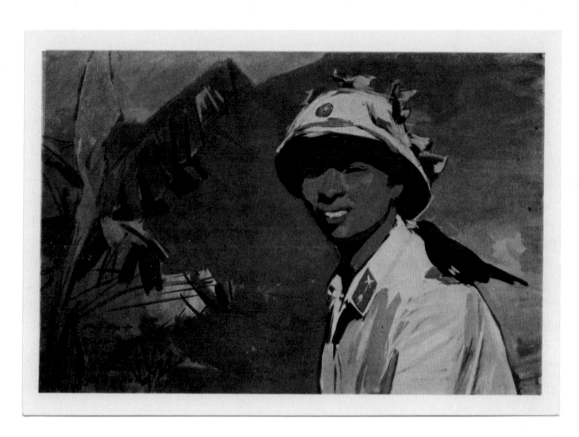

Изд. № 16-340
Т. 1-я. З. 1675
Тираж 17 000
Цена 3 коп.

СОВЕТСКИЙ ХУДОЖНИК МОСКВА 1967

М. И. САМСОНОВ (Род. 1925 г.)
У переправы

At a river crossing

Like the previous card by M. I. Samsonov, this image
is designed to convey the peaceful and harmonious
nature of Vietnamese Communist society, the unspoken
comment being that this harmony is in danger from the
imperialist enemies of a socialist society and should be
supported in its struggle to defend itself.

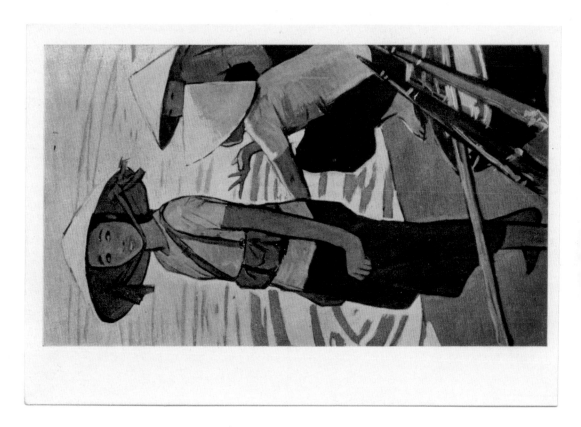

Studying socialist culture

This propaganda painting dates from the period of the Cultural Revolution in China (1964–76). On the desk of these model students are copies of the *Little Red Book*, which was required reading in every school in China. It contained a series of quotations taken from Mao Zedong's writings and speeches, which, during the height of the Cultural Revolution, were employed to indoctrinate the entire population; unity, discipline, and self-sacrificing struggle for the common good were all key concepts, as was the policy of Chinese self-sufficiency and resistance to perceived threats from foreign imperialists and reactionaries (the so-called 'paper tigers').

The expressions on the children's faces suggest their enthusiasm and dedication to the cause. In addition, the red armband the boy is wearing suggests that he is already a member of the Red Guards and the khaki jacket he is wearing indicates that in due course he will become a loyal soldier in the People's Liberation Army.

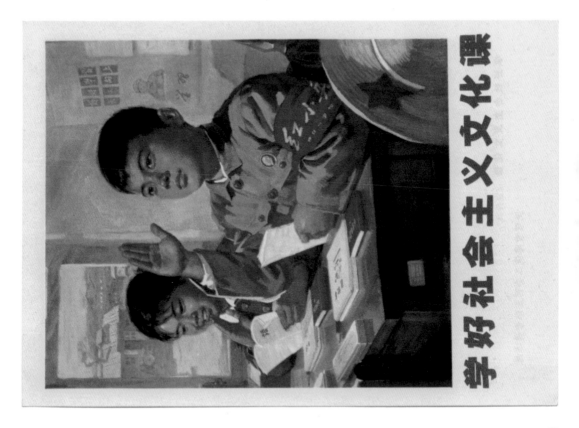

学好社会主义文化课

巡 逻 曾照欣

Patrol

The scene depicts Chinese women soldiers guarding their coastline against the perceived threat from enemies abroad. The need to maintain a heightened sense of alert against enemies of the socialist utopia, both within and without, was a constant theme in both Stalinist Russia and Maoist China and was used as a means of ensuring loyalty to the regime.

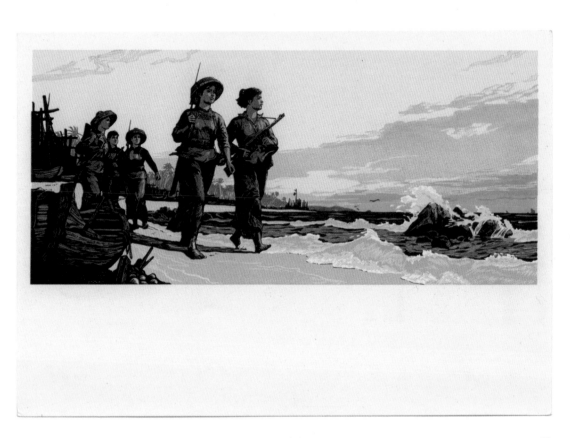

渔　家

集体创作　区焕章执笔

A fishing family

The message of this card is the same as the previous one. The family are only able to repair their nets so peacefully and calmly because of the armed militia men and women who are guarding the shore outside against the threat of foreign incursion. That this family too are prepared to fight, and even die, to defend their country and their way of life is indicated by the rifles and first-aid box neatly stacked at the rear of the cabin, whilst the radio is there to give them early warning of any attack. The only things that seem to be missing from this purposefully calm and resolute scene are any baskets of fish.

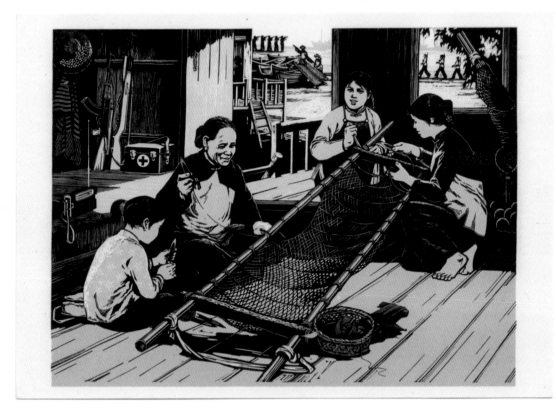

中国人民解放军美术 涂克製

"我是海燕" (油画)

'I'm a storm petrel!'

Resolution and determination to modernize the country whatever the difficulties faced is the message of this card, which shows a woman telephone engineer heroically battling to maintain the network. The liberation of women, allowing them to undertake skilled jobs such as this, was also a major plank of socialist ideology. Unfortunately this was also used to justify the conscription of women into labour battalions carrying out little more than hard manual work.

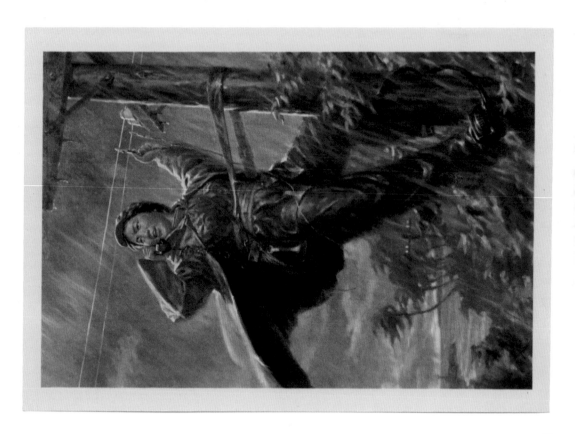

红太阳光辉暖万代 (中国画)　　　　　尤佐田

The radiance of the red sun warms generation after generation

Improvement in educational standards was a key policy of Communist countries. However, schools were also seen as vital in indoctrinating the younger generation, and it seems likely from the expression on this teacher's face that she is doing no more than reading some of the sayings of Mao Zedong to the class, whose cheerful and attentive demeanour suggests their eagerness to follow the precepts of the 'Great Helmsman'.

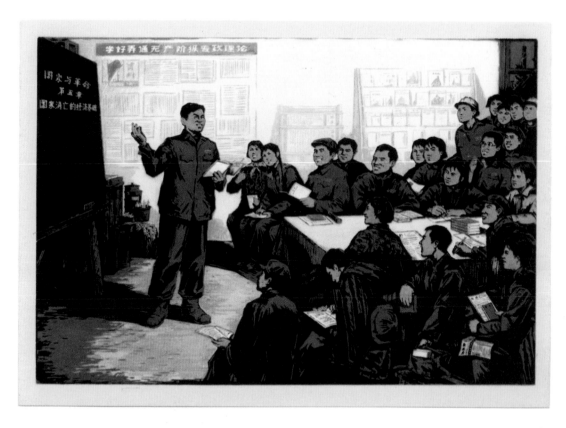

101

"五·七"指示照征途　继续革命不停步

9

The 'Five Seven' directive lights up our journey: we will continue the revolution unceasingly!

The caption to this card refers to the directive of 7 May 1966 in which Mao endorsed the proposal that members of the armed forces should participate in industrial and agricultural work. 'In this way', he wrote, 'the tremendous power of several million soldiers will be felt,' with the aim that the army and the people should 'unite as one' to participate in the revolutionary struggle.

The card depicts a group of these seconded soldiers (men and women) striding out joyfully and purposefully to help build up the country's industrial and agricultural infrastructure. It is interesting that even at this late date, and in an industrial setting, the tractor should still take centre stage as the symbol of modernization.

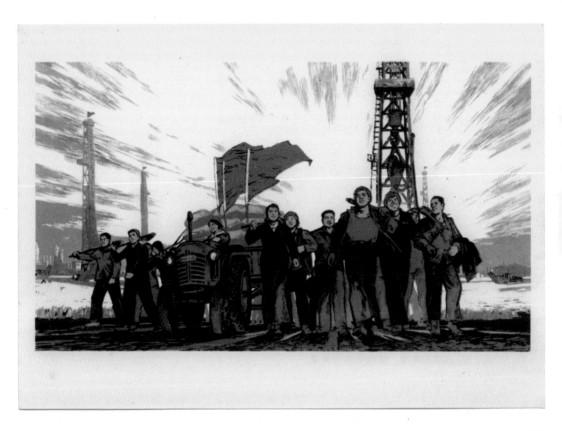

毛主席视察抚顺 (油画)　　　　　辽宁省宣传馆美术创作组

Chairman Mao inspecting Fushun

Fushun is an industrial city in north-east China. It is a centre for many types of mining but is perhaps best known as being the location of the world's largest open-cast coal mine. This card suggests that the area's industrial development and modernization (and by implication that of the country as a whole) is due to the wise guidance of Chairman Mao, who is overseeing this giant industrial complex with the full support of the planners, symbolized by the figure on the right, and the workers, who can be seen enthusiastically climbing up the hill behind him.

Fushun is also important in Chinese Communist history as being the place where the revolutionary hero Lei Feng died in 1962 at the age of twenty-one. An orphan, his life of selfless devotion to Mao later became enshrined in the Learn From Comrade Lei Feng campaign in which Chinese youth were encouraged to follow his example.

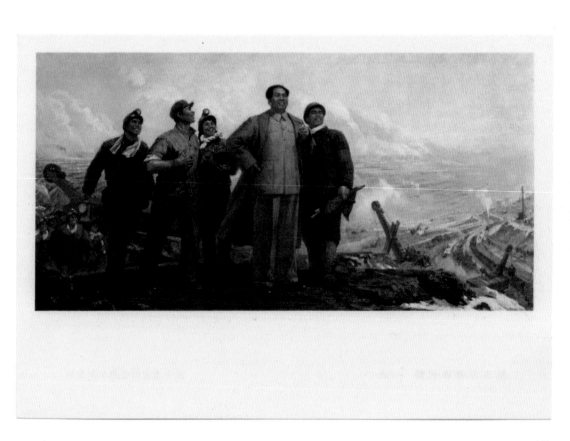

毛主席和我们心连心 (油画) 陕西省美术创作组

Chairman Mao's heart and our hearts beat as one

The image of the leader as teacher and friend of the masses goes back to the very beginning of Communism as an ideology. Here Chairman Mao relaxes over a cup of tea with a group of 'ordinary' people. From his pose he appears to be explaining some point of party policy or doctrine to them, whilst they eagerly hang on his every word. Such informal encounters were extremely rare in reality, but the card suggests that they *might* occur to any ordinary citizen. Thus the leader could be perceived as just one of themselves.

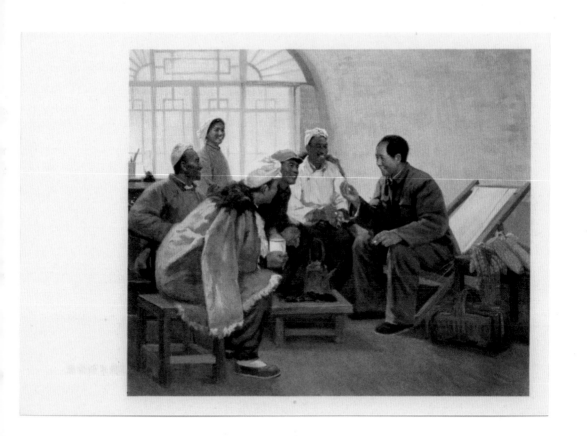